British Museum Objects in Focus

Hoa Hakananai'a

Jo Anne Van Tilburg

THE BRITISH MUSEUM PRESS

First published in 2004 by
The British Museum Press
A division of The British Museum
Company Ltd
38 Russell Square
London WC1B 3QQ

Reprinted 2010

A catalogue record for this book is
available from the British Library

ISBN 978 0 7141 5024 6

Designed by Esterson Associates
Typeset in Akzidenz-Grotesque
Printed and bound in China by
C&C Offset Printing Co.,Ltd.

Map by ML Design

Contents

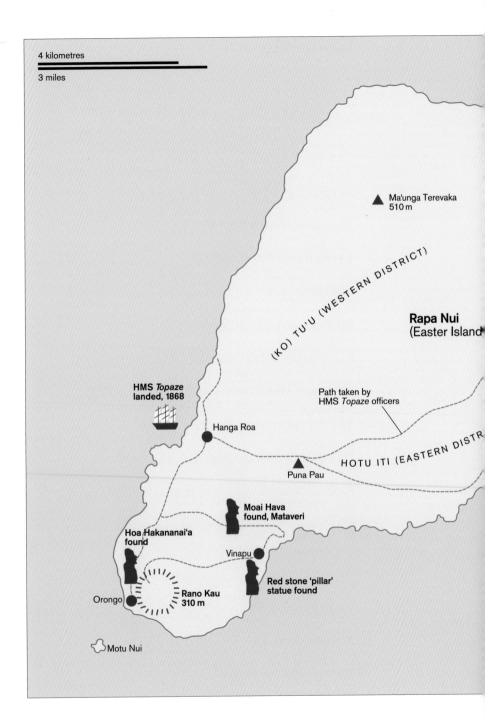

4 kilometres

3 miles

▲ Ma'unga Terevaka
510 m

(KO) TU'U (WESTERN DISTRICT)

Rapa Nui
(Easter Island

HMS *Topaze*
landed, 1868

Hanga Roa

Path taken by
HMS *Topaze* officers

HOTU ITI (EASTERN DISTR

▲ Puna Pau

**Moai Hava
found, Mataveri**

**Hoa Hakananai'a
found**

Vinapu

**Red stone 'pillar'
statue found**

Orongo

Rano Kau
310 m

Motu Nui

apanui settlement
arty landed, pre-AD 800

nakena

La Pérouse Bay

Pua Ka Tiki
(Poike)
460 m

**Rano Raraku
statue quarry**

Philippines

Hawaii

Central
America

Micronesia

Melanesia

Polynesia

Galapagos Islands

Tahiti

Marquesas Islands

Pitcairn Island

South
America

Australia

Fiji

Tonga

Austral Islands

New Zealand

Mangareva Island

Rapa Nui
(Easter Island)

5

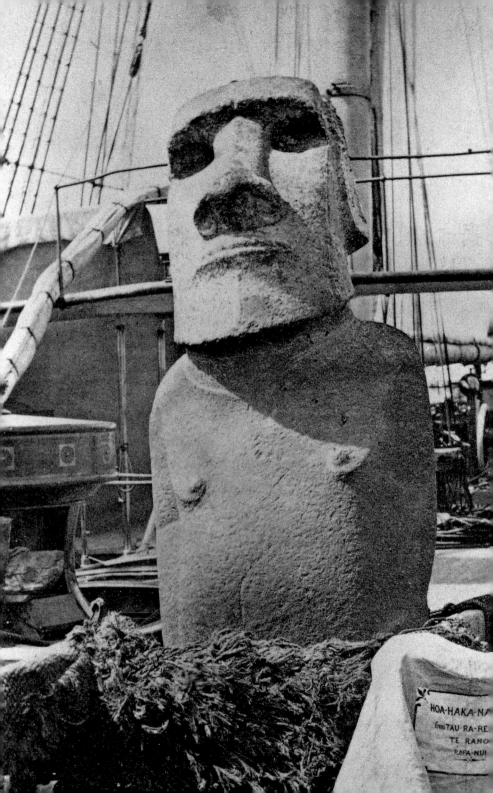

HOA-HAKA-N
from TAU-RA-RE
TE RANO
RAPA-NUI

Prologue

Commodore of the 2nd Class Richard Ashmore Powell, CB, in command of HMS *Topaze*, wrote from Valparaiso, Chile, on 3 December 1868 to the Secretary of the Admiralty. He requested that the Lords Commissioners of the Admiralty accept a 'perfect', albeit 'rudely carved', statue (*moai*) from Rapa Nui (Easter Island).[1] Its back, he said, was covered with unusual symbols. Powell was referring to Hoa Hakananaiʻa, but he failed to mention that a second statue, Moai Hava, was also on board.

On 25 August 1869 the late summer sun shone bright and warm over Portsmouth harbour where HMS *Topaze* was docked after her long Pacific voyage. Freed from its deck lashings but still surrounded by the wooden raft on which it had been floated out from the island's shore, Hoa Hakananaiʻa, his stone eye sockets empty, stood upright on deck (fig. 1). A label painted on canvas read 'HOA-HAKA-NANA-IA FROM TAU-RA-RENGA TE RANO RAPA-NUI'. Visitors and press alike marvelled at the exotic sculpture.

That same day the Admiralty wrote to the British Museum's Principal Librarian, John Winter Jones, regarding Hoa Hakananaiʻa: 'My Lords having offered the statue to Her Majesty the Queen have received an intimation of Her Majesty's desire that it should be presented to the British Museum.'[2] He enclosed an extract from Powell's letter and asked how and when the statue should be conveyed to the Museum. On 8 September the Admiralty – apparently still unaware of Moai Hava – informed Winter Jones that Hoa Hakananaiʻa was being shipped that day aboard *Buffalo* from Devonport to the Royal Victoria Naval Yard, Deptford. Captain Robert Allen received the shipment and then told Winter Jones that it actually consisted of two statues.

Since the statues were the first ever removed from Easter Island, Augustus Wollaston Franks, head of the

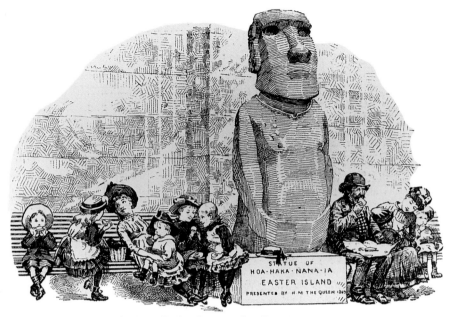

STATUE OF
HOA·HAKA·NANA·IA
EASTER ISLAND
PRESENTED BY H. M. THE QUEEN 1869

An Easter Monday Group round an Easter Island Statue.

2 Hoa Hakananai'a and the British public, 1887.

3 Front view of Hoa Hakananai'a (*c.* AD 1400), *moai* collected at Rano Kau, Orongo, Rapa Nui, 1868. Height 2.42 m.

Department of British and Medieval Antiquities and Ethnography, regarded them as valuable additions to the Museum's collection and apparently argued that both should be accepted. On 6 October 1869 he reported the statues' arrival at the Museum to the Trustees. Winter Jones was informed by the Admiralty that Hoa Hakananai'a was being presented to the Museum by the Queen and Moai Hava by the Admiralty.

In 1870 the first known published sketches of Hoa Hakananai'a and Moai Hava appeared in the *Builder*, and by 9 April 1887 the statues were familiar enough to the Museum's visitors to be caricatured in the *Illustrated London News* (fig. 2):

> One of the first objects of their [the Easter Monday crowd's] astonishment, in the very portico, is likely to be the rudely-formed statues of unknown personages,

8

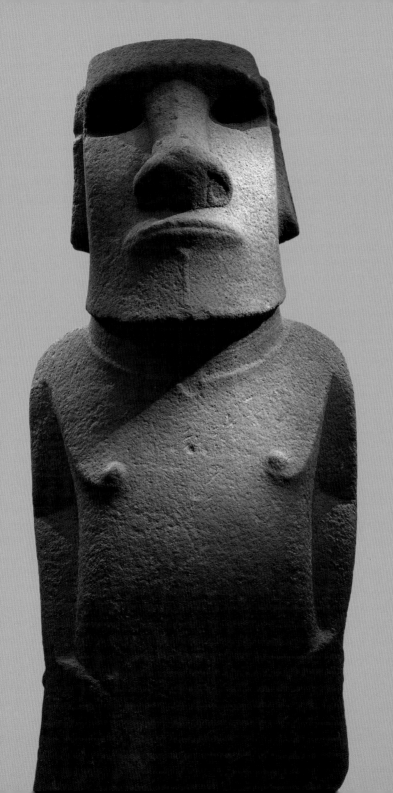

the work of an unknown extinct race of men, brought from Easter Island, in the Pacific Ocean, which is an ethnological mystery that none can solve.

In July 1910 the *London Magazine* described the impression the statues, now on the east side of the colonnade facing west, made upon viewers:

> The visitor to the British Museum, in passing through the main gates, and approaching the entrance door, may observe to his right, placed on the edge of the portico that surrounds the building, two curious statues. The inscription upon their pedestals informs him that they were brought from Easter Island, in the Pacific Ocean.
>
> The features strike the onlooker with a certain indefinable feeling of awe. The expression of the faces, though serene, is sternly disdainful; the pose of the head slightly tilted upwards; the eye-sockets sunk deep, the eyebrows massive; the nose broad, aquiline, and prominent, the nostrils widely dilated; the ears, comparatively rudely carved, have long pendant lobes.

The statues remained on the colonnade until 1940, when wartime forced the Museum's closure and they were positioned in a safer location in the Front Hall. When the Department of Ethnography was relocated to the Museum of Mankind, Burlington Gardens, in 1970, Hoa Hakananai'a was installed there, and Moai Hava was placed in storage.

Hoa Hakananai'a was returned to the British Museum in 2000 and is now installed in the new Wellcome Trust Gallery (fig. 3), where its carved back is well lit and available for viewing. The gallery leads directly off the Great Court and is the main connection for thousands of visitors every year to the north part of the Museum. Today Hoa Hakananai'a stands, a bold ambassador to the world of Rapanui art and culture, on a pedestal well above the throng and facing in the general direction of Rapa Nui. It is 13,640 km from London to Rapa Nui, but in 2003 the statue's outreach was extended even further when its visage

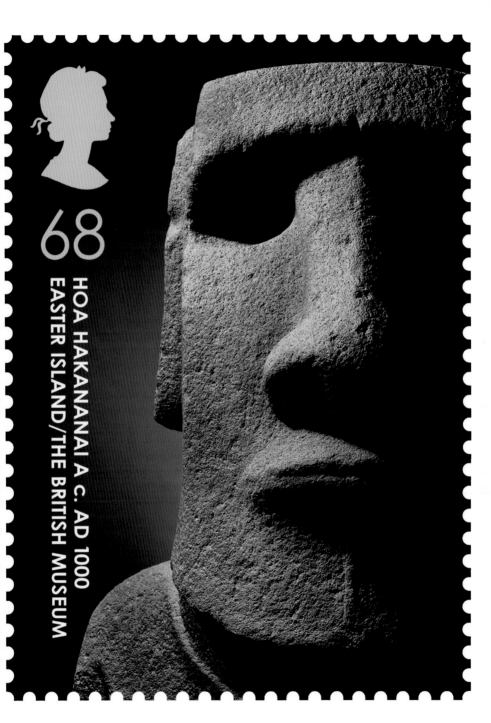

68

HOA HAKANANAI A C. AD 1000
EASTER ISLAND/THE BRITISH MUSEUM

appeared on a commemorative Royal Mail postage stamp honouring the British Museum's 250th anniversary (fig. 4).

This book will describe how, when and by whom Hoa Hakananai'a was collected. It will reconstruct the underlying Rapanui aesthetic and social structure that produced Hoa Hakananai'a, and which has been obscured by time and historical accident. There are six tools that allow this to be done, three of which I have forged: the context discerned in descriptive data collected from nearly a thousand *moai* and set within the broader revelations of modern archaeology; the anthropological insight gained from long and intimate association with the Rapanui community; and a study of hundreds of Rapanui objects in museum collections.

Other interpretive tools are, firstly, the accounts by HMS *Topaze* officers of the events leading up to or surrounding the removal of Hoa Hakananai'a; secondly, the information encoded in the form, features and symbols of Hoa Hakananai'a itself; and, finally, the ethnographic records collected by Katherine Routledge, co-leader of the Mana Expedition to Easter Island, 1914–15. They provide eye-witness testimony to the statue's ceremonial use during historical time.

Rapanui legend

According to Rapanui legend, two double-hulled voyaging canoes landed first on Motu Nui, the largest (3 ha) of three islets; it lies about 2 km off the flank of Rano Kau (Kao), a massive, water-filled volcano that rises 310 m above sea level. The canoes – one led by Hotu Matu'a, the hereditary, 'paramount chief' (*ariki mau*), and the other by Tu'u Ko Ihu, a brilliant carver – then raced in opposite directions. They arrived nearly simultaneously at 'Anakena, a crescent of white sand on the north shore of Rapa Nui (fig. 5). Hotu Matu'a stilled the paddles of the other canoe using magical power (*mana*) and landed first. On arrival, the wives of both men gave birth: a son to Hotu Matu'a and a daughter to Tu'u Ko Ihu.

No matter how mythical these legends are, they nonetheless symbolize a basic structural tension in all

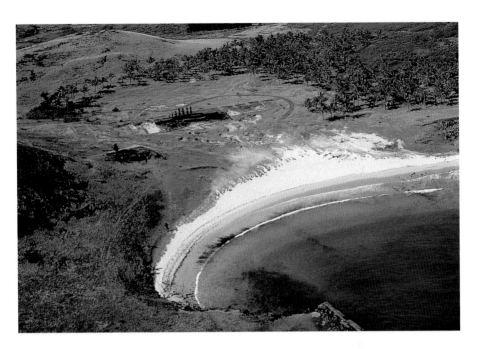

Polynesian societies: the inherent *mana* and privilege of the aristocratic, senior male line is set against the acquired *mana* that artisans such as Tu'u Ko Ihu earned through talent. Social continuity in a small island environment depends, among other things, upon the management and control of the competition that inevitably flows whenever there is a real or perceived imbalance between such opposing characteristics.

Hotu Matu'a's home island is said to have been Marae Renga, in the mythical land of Hiva. Current research suggests Mangareva or possibly Pitcairn as a point of origin for the Rapanui people. Pitcairn, although 2,000 km away, is Rapa Nui's nearest neighbour. It was inhabited and abandoned by Polynesians who made statues of red volcanic stone and traded with Mangareva. More remote ancestral roots are probably in the Marquesas Islands and Austral Islands, where red stone statues were also carved. Though impressive, statues on these other islands only achieved about half of the statistically average *moai* height (4 m).

Hotu Matuʻa, like many Polynesian chiefs, was identified with sharks but also with seals, birds and white-feathered fowl. His dangerous spiritual power was concentrated in his sacred head, hands and genitals, and emanated from his eyes. His person, royal standards, emblems of office, lands and behaviour were set apart by a web of restrictions (*tapu* or *tabu*). Hotu Matuʻa and the Miru, his aristocratic direct male line, were descended from the major gods Tangaroa and Rongo. Their generative, male power entered into and interacted with the female earth essence to produce and increase fertility in all aspects of life; this fertility was made visible by food. The patron god of Hotu Matuʻa was Makemake, a creator who was born from a skull and who formed humans from red earth. At death Hotu Matuʻa joined the ranks of the gods.

The island of Rapa Nui

Rapa Nui is the most remote inhabited island in the world. It lies in the Pacific Ocean at 27 degrees south latitude and midway between the coast of South America and the Society Islands of French Polynesia. Just 160 km² and with a maximum elevation of 510 m above sea level, it sits atop the Pacific Rise at the unstable juncture of the Pacific and Nazca plates – an area so volatile that seismologists call it a 'hot spot'.

Three submarine volcanoes, the youngest of which is Maʻunga Terevaka, formed the island through eruptions at different times within the last million years. The other two formative volcanoes are Poike, the oldest, and Rano Kau, the site of the birdman religion (see pp. 23–5). The last time Terevaka erupted was about 200,000 years ago, and all three volcanoes have been dormant ever since.

Pacific winds and currents in this region generally flow from the east, but from September to May they often shift towards the west or southwest. Fish and marine mammals migrate through the region in layered zones that coincide with temperature and floating planktons – minute animal and plant species that are basic nutrients for the entire food chain. Aside from these streams of marine life, however, this part of the Pacific is so empty that nineteenth-century American whalers dubbed it the 'Desolate Region'.

Notwithstanding such isolation and marginal resources, some time after the first century AD and before AD 800, Polynesians discovered and settled uninhabited Rapa Nui. This time frame is necessarily broad since it relies upon somewhat incomplete archaeological evidence and only fragmentary oral traditions. Polynesian linguistics, genetics and prehistory, however, anchor Rapa Nui within the East Polynesian context.

By 1868, when the crew of HMS *Topaze* came ashore, the descendants of Hotu Matuʻa had transformed Rapa Nui beyond recognition. Once supporting a subtropical forest of tall trees and palms, the island was deforested and grass-covered, and half of its native plant species were extinct. Deforestation appears to have been the inevitable result of a serious imbalance between nature and culture: small island size, isolation, altitude, latitude, limited rainfall levels, slow plant regeneration cycles and other variables had created a high level of environmental fragility. Ancient Polynesian practices of clearing and burning vegetation altered that environment to provide living and gardening space for a thriving, creative megalithic culture. Unfortunately, by the time population levels reached an estimated 10–15,000 or more around AD 1500, soils are believed to have been damaged and land bird habitat was destroyed.

Before human settlement Rapa Nui was the largest rookery in the East Pacific, but at least twenty-five nesting seabird species and all terrestrial bird species were decimated. Surviving seabirds took refuge on Motu Nui and the off-shore islets, and then gradually disappeared. Lack of suitable timber resulted in the loss of large double-hulled canoes capable of bringing in migratory, deep-sea fish such as tuna and marine mammals (especially dolphin). This left only fragile, two-person outrigger canoes for use in near-shore waters. Matters may have been made worse by naturally redirected currents or winds during crucial periods, or lessening rainfall. Food shortages were a fact of life in prehistoric Polynesia, and all the island societies had strategies for dealing with them. Long-term famine, however, was a major challenge that caused warfare and threatened social institutions.

Rapanui sacred geography

The island and the major features of its landscape comprise its natural geography, but according to the Polynesian worldview the seashore, in-shore currents and off-shore waters, the sky, and the changing winds and waves are all aspects of the island's sacred geography. While no pre-European contact name for Rapa Nui as a whole is known, hundreds of geographical placenames are recorded, and many others have been lost or obscured by time and history. Everything from a single off-shore rock to a major, formative volcano was named. Natural features were used as boundaries or sightings.

Rano Raraku, a volcanic crater composed of consolidated *lapilli* ash, or tuff, is the site where 95 per cent of the nearly one thousand known *moai* were produced (fig. 6). It is located on a broad coastal plain in Hotu Iti, the eastern and lower-ranked of the island's two political districts. Hotu Iti is named after the youngest but most favoured son of Hotu Matu'a, the Rapanui society's founding ancestor (see pp. 12–14). The western, higher-ranked district, including the royal estate at 'Anakena, is called [Ko] Tu'u.

According to Rapanui genealogy, ten tribes or clans descended from the sons and grandsons of Hotu Matu'a. The highest-ranked lineage was the Miru, who held the title of 'paramount chief' (*ariki mau*). 'Anakena was the royal residence; each of the other lineages throughout the island was headed by chiefs (*ariki*) ranked under the Miru and possessing their own lands. Ancestral land was a birthright and the abode of family spirits. Commoners (*hurumanu*) held status through each chief's rank.

Major ceremonial sites (*ahu*) marking lineage lands and honouring chiefs are located in bays or landing places spread along the rocky coastline. A few *ahu* have been reconstructed, but most remain in ruins. Each *ahu* was a platform or altar surmounted by one to fifteen monolithic statues (*moai*), all facing the lineage lands (fig. 7). Other, smaller *ahu* with statues are scattered inland.

The *moai*-carving phase of Rapanui history, known as the Ahu Moai Phase, was island-wide and fairly short-lived

(AD 1000–1600). The earliest dated *ahu* on which *moai* are known is Ahu Naunau at 'Anakena. During the prosperous Ahu Moai Phase food production was apparently ample, architecture grew in complexity, and consolidation into the two large political districts of Tu'u and Hotu Iti was achieved. Statues attained the role of icons and proliferated. By 1500 the *moai* provided graphic evidence of widespread, successful interaction between chiefly power, artistic talent and status competition.

Because of their iconic nature we tend to assume that, in principle, all *moai* were dedicated to the same major ancestral god or gods – to Tangaroa or Rongo, or possibly even to Hotu Matu'a as the gods' descendant. Rapanui oral traditions, however, maintain that individual *moai* were raised on *ahu* in honour of particular, deified lineage chiefs. Ranks of other, less exalted gods and family spirits were represented as portable figures made of stone, wood, barkcloth and other natural materials. A few stone figures are related to ancestral land boundaries.

In the Polynesian tradition of large, communal sacred spaces (*marae*), all *ahu* served as altars or temples. The exact nature of the ceremonies conducted on them is no longer known, but it is assumed that they focused on fertility, birth, death and apotheosis (the raising of a chief after death to the level of a god). They were also utilized as chiefly burial places. Cremations and possibly human sacrifices took place in relation to *ahu*.

Elliptical thatched houses that sheltered chiefs and priests were close to *ahu*, and domestic structures, gardens and fields fanned out beyond them in an ordered and consistent settlement pattern. Traditional 'first fruits' ceremonies were held there by lineages in honour of their respective chiefs. Multi-lineage liaisons generated superior production, more complex architecture and greater display. Carving, moving or raising *moai* not only required ceremony, but also increased social competition, promoted political integration and fostered the production of food to supply and support the construction of all megalithic architecture and sculpture.

In addition, seasonal presentations of exotic or

7 Re-erected *moai*, with
replica eyes inserted
and head surmounted
by a *pukao* (topknot),
on the reconstructed
site of Ahu Ko Te Riku.

restricted food and goods (such as tuna or barkcloth) were made to the Miru paramount chief during 'command performances' at Ahu Naunau, 'Anakena. The attendant ceremonies were lavish demonstrations of prowess or skill, probably including chanting (*rongorongo*). During historic time chanting was a competitive event prompted by *kohau rongorongo*, wooden boards incised with carved symbols.

It is highly likely that chiefs of all grades exchanged ritual visits, and that the paramount chief embarked upon an annual or seasonal round of visits to major *ahu* sites. These visits may have coincided with predictable natural events, such as the migratory movements of fish and birds. They would have been recorded in oral history and timed by the Rapanui calendar which, as in all Polynesian societies, was lunar-based. Each chiefly visit would have been costly to his hosts in terms of time, energy and resources.

By AD 1500 the erection of *moai* on *ahu* had peaked. The construction of ceremonial sites on lands belonging to all but the most united and tradition-bound lineages ceased. From about the 1600s statues were toppled from many *ahu*, which were no longer the focal point of ritual. Most statues and *ahu* were then laboriously covered with stones to create semi-pyramidal structures that housed tombs. Statue-carving did, however, continue in Rano Raraku throughout this time.

By the end of the Ahu Moai Phase overstressed soils apparently started to produce a lower crop yield (see p. 15), resulting in adapted agricultural strategies but also political disintegration and social conflict. Yet at the time of European discovery in 1722 and throughout the eighteenth century many statues remained upright on *ahu* while others (sometimes on the same *ahu*) were overthrown. The last statues fell between 1838 and 1864. Rapanui eyewitnesses to this final, tragic period of destruction called it *huri moai* (statue overthrow), and blamed it on food shortages, wars and a failure in the belief system. By 1867 Hoa Hakananai'a was the last *moai* to be the focal point of ritual (see pp. 50–55).

The birdman religion

After about AD 1400 and during the latter part of the Ahu Moai Phase, religious emphasis shifted from the *ahu* to Rano Kau, the volcano that anchors the southwestern terminus of the island. Rano Kau was claimed by the royal lineage, the Miru, and variously used from the time of settlement. Orongo is the name given to a ceremonial centre that emerged on Rano Kau and then developed into the epicentre of the unique birdman (*tangata manu*) religion. Orongo physically and symbolically relates directly to the off-shore islet of Motu Nui, the final refuge of nesting seabirds driven from the island by human predation.

The centrepiece of birdman rites was a trial or ordeal in which a group of chiefs, or their representatives, competed to secure the first egg of the sooty tern (*Sterna fuscata*, or *manutara*) from Motu Nui. The triumphant chief then became birdman (*tangata manu*), and represented the creator god Makemake, patron god of the Miru, for one year. He gained *mana* or sacred power. He altered his appearance by shaving his head and growing his nails like talons, and spoke in a voice that was not his own. He was isolated from the community – in 'Anakena if he was from the western district or Rano Raraku if he was from the eastern – and his sexual and other activities were restricted. Secular power was accrued to his clan, and tribute in the form of food was paid to them by the other chiefs and their families.

There are four main archaeological areas related to the development and use of Rano Kau as a ceremonial centre. Vai Atare, which is on the east side of the crater, is a quarry from which dense, smooth, black basalt was cut for building purposes. Terraces thought to have been used for gardening are found there, as well as a scattering of rock art and numerous house sites. Occupation and use of this area may have been seasonal and is thought to date to the eighth century AD.

A small, unnamed *ahu* known as Complex A is suggested as the earliest ritual architecture at Rano Kau. It is positioned well back from the sea but on the inner edge of the crater and visually aligned with Poike, the island's eastern headland. Ceremonial activity at this *ahu* is

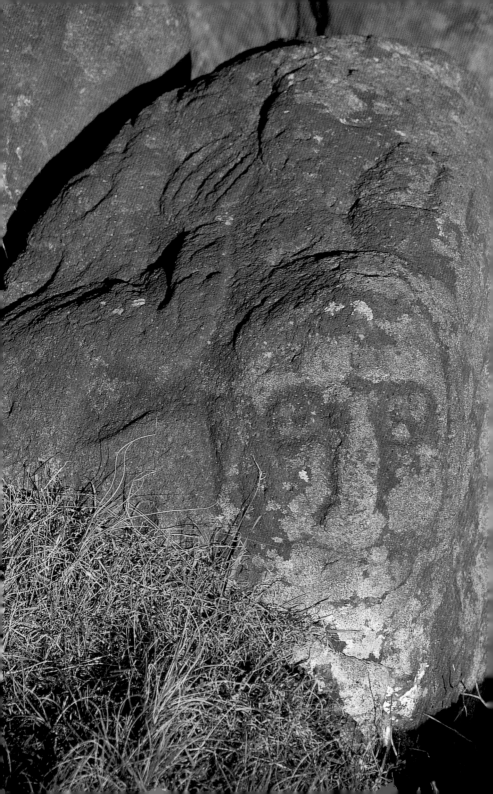

8 Petroglyph said to represent Makemake, patron god of the Miru and the Rapanui creator god (Mata Ngarau, Orongo, Rapa Nui).

presumed to have been similar to that conducted on other *ahu* but on a much smaller scale. It is within the province of the ruling Miru.

A cluster of nearly fifty, generally elliptical buildings called Complex B is set back from the outer, western edge of the crater and faces toward Motu Nui. Constructed of locally quarried basalt slabs, the buildings are dark, with low, narrow tunnel entrances. The Rapanui referred to them as caves (*'ana*). From at least AD 1500, these buildings sheltered chiefs and priests during the birdman ceremonies. Like many *ahu*, the buildings were occasionally refurbished, altered and expanded. This is thought to relate to the number of participating lineages, which also increased over time until finally the entire island was involved. The buildings were assigned to clans according to the east/west division of the island.

Complex C, Mata Ngarau, is composed of eight buildings constructed over boulders covered with petroglyphs and positioned at the most precipitous outer edge of the crater, facing Motu Nui. A special cadre of expert chanters called *tangata rongorongo*, or rongorongo men, were quartered there. They were the keepers of genealogy and oral history and apparently carvers of petroglyphs.

The volcanoes Rano Kau and Rano Raraku are both central to the sacred geography of their respective east and west districts, but both were also a resource for the whole island. They each display stone carvings expressing a highly evolved aesthetic: at Rano Raraku embodied by the three-dimensional monolithic *moai*, at Rano Kau by relief carvings. Prominent among the latter are two icons: the human head/face figures said to represent Makemake, genesis of the birdman religion (fig. 8), and the birdman itself, a human/avian form signifying the god's incarnation (fig. 9).

Missionaries on Rapa Nui

In the nineteenth century Rapanui society, which had apparently been isolated until 1722, was nearly destroyed by the abhorrent practice known in the Pacific as 'blackbirding'. From 1862 to 1863 at least twenty-two slave ships called at Rapa Nui, and as many as eight are known to have

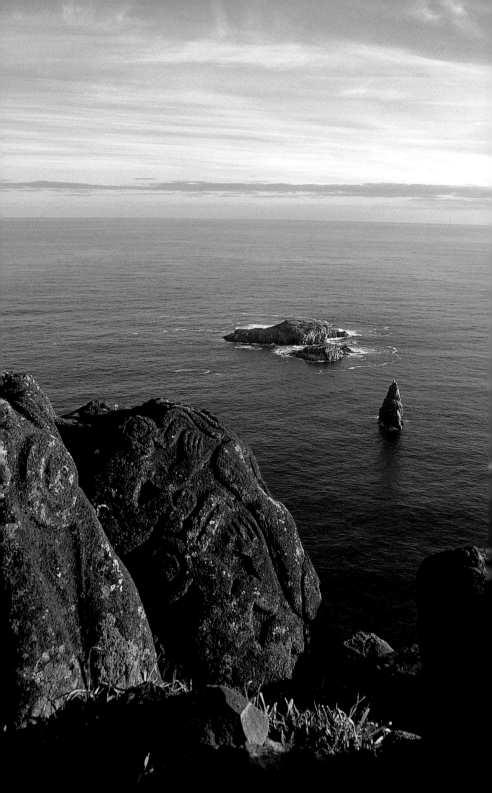

anchored off the island at one time. Rapanui people were 'recruited' or abducted against their will, transported to Peru and sold into service or as workers in the guano industry. Many of those left behind abandoned the island for French Polynesia. Although the population fell precipitously and the society was in disarray, until 1867 birdman ceremonies and initiation or coming-of-age ceremonies for children were still practised at Orongo.

Three years earlier Lay Brother Eugène Eyraud, the island's first Christian missionary, arrived to minister to the ravaged population. Missionaries are seen by some researchers as a god-send and by others as the epitome of post-European contact evil. The Rapanui, it seems, saw them in similarly conflicting ways. Eyraud fled the island at the end of his first year and then returned with four colleagues in 1866. When he died in 1868, one priest departed and only Father Hippolyte Roussel, head of the mission, and Father Gaspar Zumbohm remained.

The last Rapanui was baptized only eight days before HMS *Topaze* arrived. The islanders had been subdued by the missionaries and forced to congregate in Hanga Roa village. The Rapanui population was dying – physically and spiritually. They were desperately poor, and separated from their history and the family spirits that they believed inhabited the ancestral lands. Some were so disturbed by the new ways and strange beliefs that they rose in the night and exhumed bodies of family members from the Christian cemetery, carried them surreptitiously to ancient ceremonial sites and reburied them.

Visiting ships such as HMS *Topaze* were the islanders' only lifelines, and they eagerly pursued a highly competitive kind of early tourism. Their chief currency at the time was woodcarvings, which they had traded to explorers, whalers and slavers since at least the time of Captain Cook's arrival in 1774. Jostling to gain favours from Commodore Powell and the other *Topaze* officers was intense.

The arrival of HMS *Topaze*
HMS *Topaze*, a 2,659-ton, 600 horse power frigate on the Pacific Station (fig. 10), departed from Devonport, England,

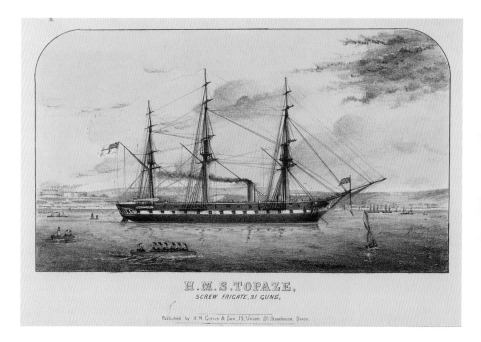

H.M.S.TOPAZE,
SCREW FRIGATE, 31 GUNS,

Published by H. M. Currie & Son, 79, Union St, Stonehouse, Devon.

10 HMS *Topaze*, frigate on the South Pacific station.

11 Lt William Metcalfe Lang, HMS *Topaze*, discoverer of Hoa Hakananai'a and officer in charge of the statue's removal to shipboard, c. 1897.

in January 1867 under the command of Commodore Powell and arrived in Valparaiso, Chile, the following May. In June she began an extensive voyage through the Marquesas Islands and Society Islands, where the officers and men became somewhat familiar with Polynesians and their ways. She returned to Valparaiso in September, and her crew witnessed the great earthquake and resultant tidal wave that struck Chile in August 1868.

Among the officers aboard *Topaze* were several who, like Powell, would play roles in the saga of Hoa Hakananai'a. Lt William Metcalfe Lang was an able officer who served out a long and productive Royal Navy career, later acting as adviser to the Chinese Navy and then head of the Naval Gunnery School in Plymouth (fig. 11). He discovered Hoa Hakananai'a and was the officer in charge of the statue's removal from Orongo to HMS *Topaze*.

Lt Matthew James Harrison joined *Topaze* in Callao, Peru. A twenty-two-year-old career officer, he later married Lucy Caroline Wedgwood, daughter of Josiah Wedgwood III and niece of Charles Darwin. His sketch of Hoa

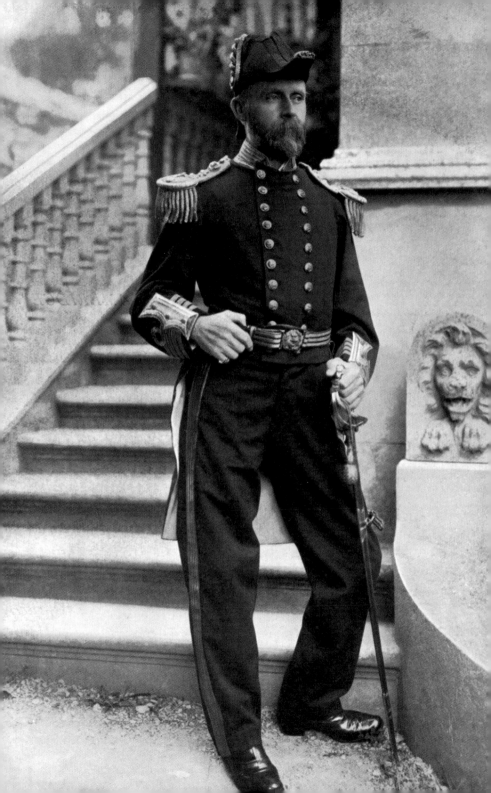

Hakananai'a *in situ* is the only certain documentation
we have of exactly where the statue was found.

The ship's surgeon, Dr John Linton Palmer, joined the
Royal Navy as an Assistant Surgeon in 1848 and was aboard
HMS *Portland* when she called at Rapa Nui in 1852. He did
not go ashore at that time, but sketched and traded with
Rapanui men and women who came out to the ship. From
that experience Palmer developed an intense curiosity
about the island, and during both visits he made sketches
and watercolours of Rapa Nui and its people. Assistant
Surgeon Charles Bailey Greenfield aided Lt Lang in the
discovery of Hoa Hakananai'a.

Lt Colin Mackenzie Dundas was an amateur botanist
who transferred a considerable number of plants from
island to island during his travels in the Royal Navy.
His journal reliably describes the movements of *Topaze*
at sea and the activities of her officers on Rapa Nui.

At 4 p.m. on 22 November 1868 Powell set his course for
Rapa Nui from Callao. His mission was to verify the island's
position on Admiralty charts, to search for other islands
reputed to be in the vicinity and to survey Rapa Nui.
HMS *Topaze* made a good run under sail – averaging about
200 miles each day for about 2,050 miles – and at sunset
on 31 October 1868 Rapa Nui was sighted.

Topaze steamed around the island's southern cliffs
towards the little beach where Captain Cook had briefly
landed in 1774. Powell anchored his ship in front of Hanga
Roa, a cluster of thatched houses built somewhat back from
the shore. Palmer sketched the view from shipboard and
Henry V. Barclay, Lieutenant of the Marines, noted that
the entire ship's company – no doubt remembering with
fondness their sojourn in more colourful French Polynesia
– was disappointed at the first sight of what seemed to them
to be a dreary landing place.

Two boats filled with Rapanui people came out to meet
Topaze, and many clambered on board to barter. Father
Roussel was with them, as was Torometi, a fearsome
Rapanui war chief, and a Frenchman named Jean Baptiste
Dutrou-Bornier. A fortune-seeker with a long and violent
history on Rapa Nui, Dutrou-Bornier had arrived from

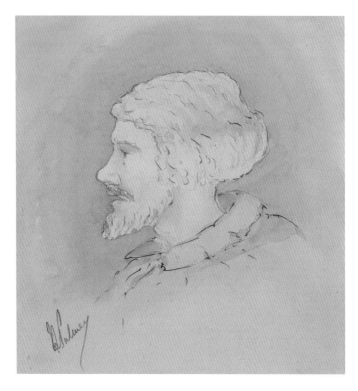

12 Torometi, the war chief who aided in the removal of Hoa Hakananai'a, at church services aboard HMS *Topaze*, off Hanga Roa, Rapa Nui, 1868.

Tahiti in 1866 when he delivered Roussel and the other missionaries to the island. Just eight months before the arrival of *Topaze* Dutrou-Bornier had wrecked his ship.

Lt Dundas says that Dutrou-Bornier 'and some of the chiefs have formed a species of government for the island. They have also constructed a flag for themselves – Red with a Blue cross on a White ground'.[3] Dubbed the Conseil d'Etat, the 'government' was dominated by Miru chiefs from the north coast who had been forced by Roussel to relocate to Hanga Roa. Torometi, whose ancestral lands were close to Hanga Roa, had been defeated in recent skirmishes with a Miru chief allied with Roussel. In his own self-interest, Torometi had befriended Dutrou-Bornier. The missionaries were bitterly competitive with one another, and Torometi, Dutrou-Bornier and Father Zumbohm were allied against Roussel. This cabal of tough, self-interested men was Powell's key to success on Rapa Nui.

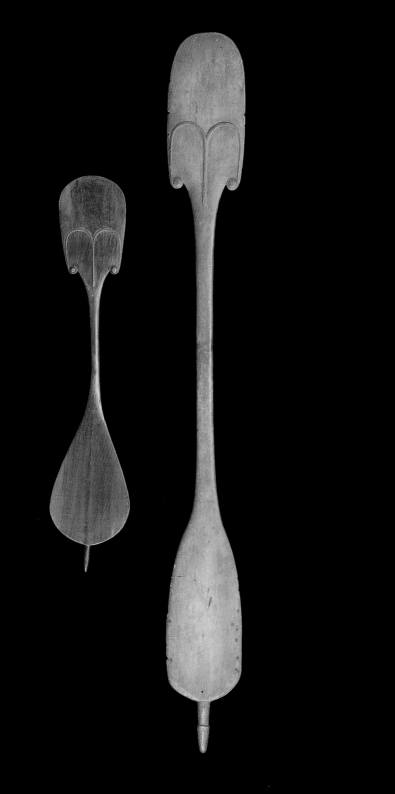

Lt Dundas says that Dutrou-Bornier 'was employed constructing a small vessel out of the wreck of his schooner to return to Tahiti & we lent him assistance in the way of carpenters, plank & nails'.[4] In exchange for that largesse, and for ship's provisions distributed by Powell to the community at Roussel's request, Rapanui men were hired as guides. At a shipboard prayer service conducted by the Revd William Deardon, Dr Palmer sketched Torometi and, tongue-in-cheek, described him as 'one of the devout attendants' who intended to have 'a finger in the pie' made by Roussel (fig. 12).[5]

A landing party was put ashore and greeted by a crowd of about two hundred Rapanui men and boys. The priests kept a watchful eye on them as they scrambled to entertain, ingratiate themselves and barter. More woodcarvings were offered; Richard Sainthill, Secretary to Powell, described some of them as 'peculiar implements shaped like canoe paddles, but used only in their dances and called "rapa"' (fig. 13).[6]

Occasionally, Sainthill goes on, the Rapanui would 'burst into a loud chant, in time to which they kept up a jumping dance, their arms working about, and the "nua", a garment tied loosely across their shoulders, flying out from their naked bodies in the wind. The scene was sufficiently wild, and the eyes of some of them watched us with a droll expression, as though they thought they would rather surprise us.'

The Rapanui men and the officers of *Topaze* understood that they were all participants in a staged drama. Lt Harrison said, 'I very much doubt if they understand much about their religion, as any one of them would have been glad to sell his crucifix for 20 cents.'[7] Nonetheless, Father Roussel impressed Powell as a determined and commanding presence, a man who had managed to tame, control and indoctrinate the Rapanui community. Roussel, however, may have seen such displays as dangerously heathen throwbacks to an earlier time.

The next day at 8 a.m. Powell put working parties of six men each ashore. The officers were Lt Harrison, Lt Dundas, Richard Sainthill and Dr Palmer, and they were

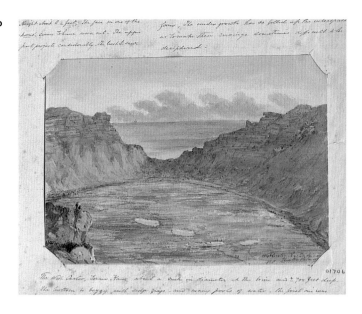

accompanied by unnamed Rapanui guides. At least some of
the officers knew a smattering of French, and the islanders
probably had a limited vocabulary in that language.
Palmer says that when the Rapanui lacked words they
enthusiastically acted out their meaning.

Sainthill describes how the guides led them to 'an ugly
lump of stone, about four feet high, almost featureless; they
called him Moai Hava'.[8] Moai Hava was not standing on
a ceremonial platform and was nearly completely buried.
Dundas noted the statue's approximate position on his
sketch map; the area in which it was found is known today
as Mataveri. The gathering place of clans, Mataveri was
the centre for provisioning chiefs and priests residing at
Orongo during birdman rituals.

Sainthill's unfavourable impression of the statue was
shared by Dundas, who thought it was very small and
weathered. *Hava* means 'dirty (rejected, repudiated)'
in Rapanui, but another interpretation of it is 'to be lost'.
Modern Rapanui consultants relate the word to loss or
to crying over loss. Palmer was told that there were many
burials in the area where the statue was found. The statue's
name (and, in fact, its upward turn of face and head) may

34

thus relate to keening at death. It may also mean 'lost' as in 'taken off the island'. Dutrou-Bornier sent some Rapanui men to bring the statue to the shore near Hanga Roa.

One *Topaze* shore party followed a trail that looped along the coast and then ascended nearby Rano Kau. They scrambled down the volcano's steep inner slope and took the welcome opportunity to bathe in its large freshwater lake (fig. 14). The next morning the same party again went out. They briefly explored a small cinder crater called Terano Hau (Puna Pau), source of the red volcanic stone cylinders (*ha'u* or *pukao*) that had once balanced precariously on the heads of about a hundred standing statues. Some cylinders were etched with crescent shapes, birds or other designs.

They then walked along an inland trail to the island's eastern territory, Hotu Iti, and explored Rano Raraku, the volcanic ash statue quarry. In Palmer's drawings Rano Raraku statues are erroneously shown with carved eye sockets. Only statues that once stood erect on ceremonial platforms (*ahu*) had carved sockets, and Palmer was told that eyeballs had once been inserted into them. After returning to the ship at about 6 p.m. Harrison presented their delighted guides, who were dressed only in loincloths (*hami*) and capes, with white trousers and shirts.

Orongo and the discovery of Hoa Hakananai'a

The next day Powell, impressed with the number of archaeological remains and apparently seeking a bigger and more impressive 'souvenir' than Moai Hava, sent out three parties, again with Rapanui guides. One party, with Lt Dundas as surveyor, landed by boat at La Pérouse Bay and again explored Rano Raraku. The second, including Palmer and Harrison, walked out to the ceremonial site of Vinapu.

Captain Cook's men had seen upright statues on at least one of two important *ahu* at Vinapu, but by 1868 they were all toppled. At one of the Vinapu *ahu*, Rapanui guides showed Palmer a very interesting red volcanic stone 'pillar' statue with two carved faces. It stood on a pedestal of the same red stone and atop a paved area. At its base were burned human bones. Palmer was told that the statue

was one of many which used to stand near the ceremonial platforms, and that the bones were of 'victims'. The statue was not deemed worthy of collection, but Palmer sketched it with one of the Rapanui guides standing in traditional garb beside it.

The third *Topaze* party headed straight to the volcano Rano Kau. Among the officers were Richard Sainthill, Lt Lang and Assistant Surgeon Greenfield. The identity of the Rapanui men who guided them is not known, but Father Zumbohm probably accompanied the party. The officers entered each of Orongo's stone buildings in turn, searching them methodically on their hands and knees (fig. 15). They found red and white paintings on flat stone slabs fixed into the walls opposite the doors. Sainthill thought one of them was a *rapa* with the upper portion of the paddle marked with human eyes, nose and mouth. On one slab a fully rigged ship was painted, the sailors dancing jigs and a flag waving from the main-royal yard-arm.

It was here at Orongo that Lt Lang, with Dr Greenfield assisting, discovered Hoa Hakananai'a. The statue was standing upright in one of the buildings, directly opposite the door and buried to its shoulders. Its back was to the sea and it faced northwest, away from the entrance and, as a consequence, towards the island and the western district.

Sainthill recognized carvings of birds and *rapa* on the back
of the head. Dundas, who was not present, later reported
that the back of the statue and the face were painted white,
and that the carvings were red. The perfection of the
half-buried statue, even in the musty dark of the Orongo
building, was impressive.

If the *Topaze* officers knew in advance that Hoa
Hakananai'a was at Orongo, they clearly did not know
precisely where to look for it. The self-interested trio of
Dutrou-Bornier, Torometi and Zumbohm all gained from
the statue's discovery. Dutrou-Bornier was indebted to
Powell for shipbuilding materials, and Hoa Hakananai'a
was an impressive repayment for that favour. If Torometi
told Dutrou-Bornier about Hoa Hakananai'a, he certainly
expected to be paid for the information. Zumbohm and
Roussel, even though they were at odds with one another,
were both eager to rid the island of this powerful, only
recently used non-Christian religious symbol.

Lt Harrison sketched the statue *in situ*. He recorded the
statue's name as 'Hoa Hāka Nāna Ia (the first two names

being as far as we could understand his title)' (fig. 16).[9] Variations of that spelling were recorded by Palmer and Dundas, and the likely translation is 'stolen or hidden friend'. The name is descriptive, somewhat derisive and possibly coined on the spot. It is a condensed phrase, and variations in inflection and emphasis in the spoken words produce subtle shades of meaning. This single Rapanui phrase literally describes 'a *moai* which represents a certain kind of friend, which has been stolen and hidden (in Orongo) and is now being taken away yet again, this time to be hidden from the island'.

The name of the building in which Hoa Hakananai'a was found was Taura renga. Forty men demolished it to retrieve the statue. The following morning Powell sent sixty men to collect the statue, and Dundas says that they transported it on a sledge made of ship's bars. They dragged the load broadside-on over the softer ground and base-first up steeper slopes. Barclay's account of transporting the statue differs in details, but he says the task was made easier by many willing hands. The event was so memorable that, as late as 1914, a famous Rapanui woman named Veriamu could sing the song of the English sailors as they hauled Hoa Hakananai'a from Orongo to the sea.

In 1884 a Rapanui man known as Tepano, who recalled Palmer well, was interviewed in Tahiti. He had a roughly scratched tattoo on his left forearm that is as much an historical document as are the sketches made by Harrison and Palmer. On it a dancing Rapanui chieftain (perhaps Torometi) follows the supine body of Hoa Hakananai'a as it is dragged by five pairs of English sailors. Two officers, one carrying a staff, are the First (Lt Lang) and Second Officers.

On 7 November at 1 p.m. Hoa Hakananai'a was floated out on a specially built raft and hoisted aboard HMS *Topaze* amidst the cheers of the islanders. Palmer and Dundas both noted that the red and white pigment on it was inadvertently washed off. The Conseil d'Etat asked Powell to carry a petition – the first of five – to the French Consulate in Valparaiso, probably as a return favour for help offered on the island. It requested that France accept the impoverished island as a protectorate. As the ship's 5 p.m.

departure time neared, desperate Rapanui begged to sail with her. When the last boat shoved off it was nearly impossible to get them to disembark.

The *moai* of Rano Raraku

Rano Raraku, in the eastern political division of Rapa Nui known as Hotu Iti, is the most culturally significant resource on the island. Without it, Rapanui artisans probably would have carved statues in wood or stone. With its relatively soft volcanic ash, however, they were able to carve nearly a thousand statues, almost all of which surpass in size and mass anything similar in the Marquesas Islands or Austral Islands.

Rano Raraku is awkwardly shaped, with steeply rising cliffs on its southeast side and much lower, softer, eroded slopes on the northwestern side. Nearly four hundred *moai* still remain in Rano Raraku. The tallest is a massive carving 20.56 m high and weighing at least 200 tons; it is still unfinished and attached to bedrock. The most frequently photographed, best-preserved and beautifully carved *moai* are embedded upright in the soil of the exterior slopes (fig. 17). Others, similarly embedded, stud the interior slopes.

From at least AD 1000 Rano Raraku was an established production centre for *moai* and the beating heart of Rapa Nui's energetic megalithic society. Statues were the only objects ever carved from Rano Raraku tuff, although some were quarried out of older, unfinished or abandoned figures. The reshaping of discarded or damaged statues into building blocks or the incorporation of them into *ahu* architecture also took place, but such uses were not indiscriminate or without symbolic meaning.

The base of Rano Raraku is ringed, at about the same contour level, with the stone foundations of twenty-six elliptical structures possibly once occupied by priests of the carving profession or master carvers (*tangata maori anga moai maea*). Craftsmen had their own insignia and rituals, and were responsible for maintaining traditional methods and standards, managing the outcome of work projects and training apprentice learners. High status through birth was not a prerequisite for entering the carving profession, but

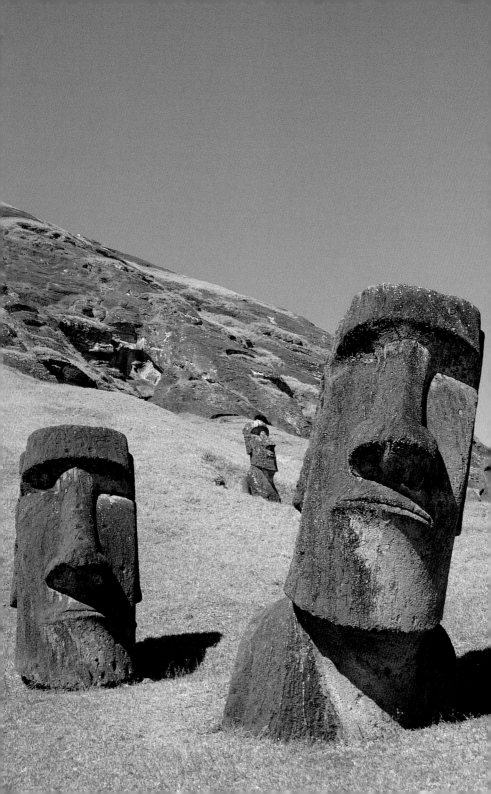

17 Two well-carved
moai embedded on the
exterior slope of Rano
Raraku, Rapa Nui.

skill demonstrated through mastery was absolutely essential
for remaining in it and prospering. Honour, success and
reward were palpable evidence of *mana*, or spiritual power.

Individual quarries within both the interior and exterior
of Rano Raraku were not usually linked to each other, but
internally most show a degree of planning. Some quarries
appear to have been practice or teaching areas for such
important features as statue heads and faces. Each quarry
was probably supervised and managed by an individual
master carver.

Rano Raraku tuff is orange-red when freshly cut, and
in some cases it is yellow. As the tuff ages it hardens and
darkens. Volcanic stone quarried in small local quarries
elsewhere has a deeper, blood-red colour. It was used to
carve about twenty-five known *moai*, none of which stood
on ceremonial platforms. Red cylinders (*pukao*) were
quarried in Puna Pau and then placed on the heads of about
a hundred *moai* carved in Rano Raraku. That same red
stone was used for architectural enhancement of the largest
or more complex *ahu* and was scattered, with white coral,
over burials and crematoria.

This preference for red and reddish hues is rooted in the
Polynesian belief that red is a sacred colour. Red stone was
chosen to carve monolithic statues in the Austral Islands,
the Marquesas Islands and on Pitcairn Island. Rapanui
legend associates red not only with the god Makemake
and his creation of humans from red earth, but also with
warriors and warfare. In the eighteenth and nineteenth
centuries fine-grained hardwood of the *Sophora toromiro*
tree was favoured in woodcarving. Like Rano Raraku tuff
it changes with time and exposure to the elements: when
young it is yellowish, but with age turns quite red. In both
cases, it can be assumed that such inherent colour change
did not go unnoticed and was probably valued.

In Rano Raraku narrow canals, some very steep and
dangerous, were cut into the bedrock alongside and at the
top and bottom of roughed-out blocks, and were used by
carvers who stood in them to work. All statues were carved
by what is called the 'reduction method' (fig. 18). That is,
they were first shaped as rectangular blocks or 'blanks',

18 Supine, incomplete statue still attached to bedrock and apparently abandoned in the process of carving, Rano Raraku, Rapa Nui.

and then their mass was gradually reduced. The rough-out tools used at this stage were flaked basalt picks (*toki*). Perfunctorily made and easily discarded, quantities of these tools may still be found in Rano Raraku. They were held in the hand without any sort of haft, or handle. Other types of tool were used at later stages of carving.

A shallow groove roughly cut in from each side at the neck divided the two parts of the statue 'blank'. This is similar to the way in which Rapanui experts shaped a good piece of basalt to form a finely crafted adze. This parallel in technique was certainly recognized and understood by master carvers, and some very interesting rock art in the interior quarry roughly recreates the procedure in miniature.

The obvious position for adding the features and details of each statue was face-up, but a few nearly finished *moai* are lying on their sides. The heads and faces of nearly all statues were carved first, in keeping with their ritual importance; the elongated nose also facilitated the accurate placement of torso details. No statue in Rano Raraku, or in transport to a ceremonial platform (*ahu*), has eye sockets. These were carved only after the statues were erect on *ahu*. Coral and red scoria eyeballs were inserted in sockets

during ceremonies, ritually opening the eyes and profoundly changing the appearance and expression of the *moai*.

The ears on nearly all *moai* have extended lobes. They were blocked out and then finished by incising linear and curvilinear patterns that vary within a predictable range. All *moai* have distinctively overlarge hands and fingers, and thumbs that sweep gracefully upward, with an unrealistic curve to the lower edges of the wrists. This convention gives the hands, especially in the larger and later statues, the distinctive sweep of birds' wings. The wing-like hands of the *moai* are the inverse of the human hands shown in carvings of the birdman, but both express human/avian unity.

All frontal details were finished before the statues were moved out of their individual quarries. Each torso is marked by nipples and a navel carved in relief and always about the same size. These three points are emphasized as a sculptural comment on their natural relationship to birth and sustenance. The nipples are the termination of curved or occasionally slightly chevron-shaped rib-like lines which extend from the front of each arm just below the shoulder. The fingers of all *moai* reach either side of a distinctively shaped element that represents the *hami*, or loincloth, and indicates male gender.

A bas-relief carving first noted by Katherine Routledge and called by her the 'ring and girdle' appears on the backs of many statues. This is an extension of the *hami*, and represents the Rapanui form of the Polynesian *maro*, or loincloth. It consists of single, double or triple curved lines (inverted crescents), usually surmounted by one or two circles that arch across the small of the back and disappear under the elbow. The length of the *maro* was indicative of wealth and therefore status. It follows that the most complex 'ring and girdle' represents the longest *maro*.

About 150 statues remain on the interior and exterior slopes of Rano Raraku. The fact that many of them are embedded upright in the soil has been explained for a long time by the purely functional need to finish their backs, but this is, I believe, only partly accurate. While an upright position was certainly required for finishing, there are no *ahu* prepared anywhere on the island to receive these

statues. Several of them, in fact, are standing on stone pavements; one statue in the interior of Rano Raraku was dropped into a hole hollowed out of solid bedrock, an obviously labour-intensive and unnecessary effort if only temporary placement was intended.

All the statues standing in Rano Raraku are so deeply embedded that the fine details of hands and *hami* are covered. This appears to be a deliberate act and not the result of soils washing down the slope over a long time period, as has been suggested. In my view, most of the standing statues in Rano Raraku were deliberately retained there. Those on the volcano's exterior slopes, especially, provide a very strong visual image of concentrated power in Hotu Iti, the island's lesser-ranked, eastern political division. They balance the power inherent in the many birdman symbols carved at Orongo, in the west.

Several theories about statue transport have been advanced, some more reasonable than others. It is highly unlikely that one method worked in all cases, and strategies certainly varied with terrain, statue size, chiefly power and available natural resources. In Polynesian pre-industrial technology, builders of houses and makers of canoes used a defined range of tools and techniques. Following the logic that such methods would have been transferred and applied to statue transport, I conducted a full-scale experiment on Rapa Nui to make and move a precise replica *moai* of statistically average height and weight.

The replica statue was placed horizontally on a specially rigged and lashed A-frame log sled. The sled was based on simple design principles of flexibility and balance known to pre-contact Polynesian outrigger canoe-makers. Horizontal cross-beams, which were originally intended for use as rollers, were instead lashed under the sled to create a 'canoe ladder', an ingenious device used by Polynesians to haul heavy canoes up and over rocky cliff sides. Two rope crews pulled the statue and frame over parallel wood logs on relatively flat ground with ease.

This demonstrated that fifty to seventy Rapanui men, women and children could efficiently, even relatively easily, do such work. The statue, in this manner, could have

traversed nine miles in about five to seven days – an event that would certainly have been accompanied by feasting and ceremony. The average chief thus needed to mobilize about 395 to 435 people (eight-and-a-half extended families). They, in turn, produced, consumed and used (in rope-making, for example) the surplus agricultural and available timber resources of at least 50 acres of land. Foods such as crayfish and tuna were needed for the high-status chiefs, priests and master craftspeople involved. Taller or heavier statues, or rougher terrain, would require a proportionate increase in resources to the breaking point.

Hoa Hakananai'a and Rano Kau

Hoa Hakananai'a, importantly, was not quarried in Rano Raraku. Instead, it is carved of a fine-grained, medium to dark grey basalt that is smooth and even in colour and texture. Although the stone has not yet been sourced, it was probably quarried in the vicinity of Rano Kau. It is one of only ten known *moai* carved of basalt.

Basalt differs greatly from the relatively soft and easily weathered volcanic ash of Rano Raraku. It is hard and dense, more expensive to quarry, more time-consuming to carve and less forgiving of error. Only a very high-status chief would have been able to commission a statue of the quality of Hoa Hakananai'a, especially if he did so at a time when the island was suffering a general decrease in resources. However, carving the statue locally did not require access to Rano Raraku, and it eliminated transportation costs from there to Rano Kau – almost the entire length of the island. The statue's material, location at Orongo and position when found (facing northwest) all connect Hoa Hakananai'a with the ruling Miru.

Like the majority of statues, Hoa Hakananai'a is a vertically rectangular cylinder – a head and torso only. The proportionate relationship of head to torso size also fits the norm, in which the length of the torso is two-thirds greater than the length of the head at the back. This sculptural emphasis is in keeping with the Polynesian belief in the sanctity of the chiefly head. Its overall form fits well with statues carved late in the Ahu Moai Phase, the period

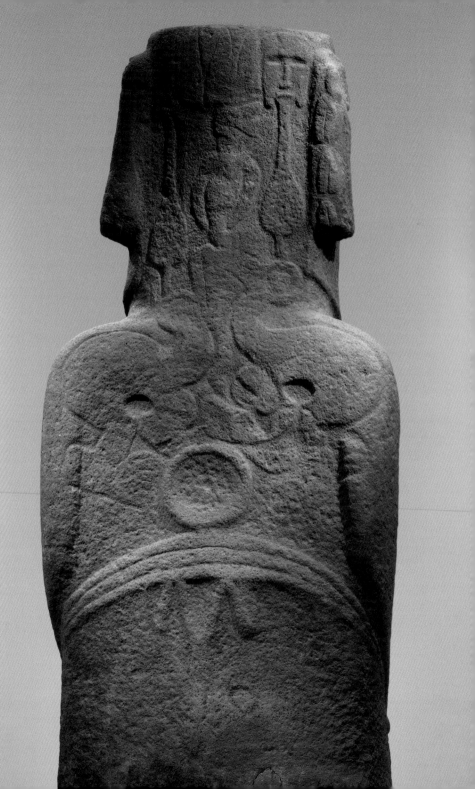

19 Dorsal view of Hoa Hakananai'a showing superimposed bas-relief and incised carvings associated with the Orongo tradition and birdman (*tangata manu*) ceremonies.

20 *Overleaf* Petroglyphs with white paint. Found in a small cave, they are said to represent the creator god Makemake.

in which the ceremonial village of Orongo and the birdman religion were beginning to grow in influence.

The depth of Hoa Hakananai'a at the mid-section is only 55 cm, making the torso markedly 'thin' in profile. The base is narrower than one would expect in a statue of this size. This is because the statue was either never perfectly or completely finished or, at some time after it was finished, the base was altered through chipping away of the stone to facilitate planting it in the ground. Alteration or lack of completion is also apparent on the back, where adze marks indicate the cutting away of a portion of the right arm to create a larger, more plane surface on which to superimpose carvings. Similarly, on the lower front of the torso, where the hands and *hami* would normally be found, there is only an awkward and out-of-proportion partial indication of hands lacking fingers.

The proportions of Hoa Hakananai'a's facial features are also within the norm. The oval eye sockets are perfectly executed and capable of holding coral and stone eyeballs. Since eye sockets are present on all statues that were once erected on *ahu*, it has been suggested that Hoa Hakananai'a was originally positioned on the small *ahu* at Orongo's Complex A. Although there is no direct evidence to support that assertion, we can presume that Hoa Hakananai'a was employed in *ahu*-type ceremony.

The oval nostrils are formed of graceful, bas-relief fish-hook shapes, in the style of basalt fish-hooks that are a hallmark of Rapanui material culture (the only other Polynesian island known to have produced stone fish-hooks is Pitcairn). On one site only, Ahu Naunau at 'Anakena – the Miru royal estate – the *moai* have bas-relief fish-hook-type designs on the buttocks. Thus, that design is probably linked to the Miru.

Hoa Hakananai'a has two rare distinguishing marks: a Y-shaped design on the chin and, on the torso, slightly offset from the centre and incorporating the line of the neck, a curved indentation representing the clavicle. Both are late innovations documented in only about a dozen statues in the entire corpus – including three of basalt. The marked clavicle is ubiquitous in late nineteenth-century Rapanui anthropomorphic woodcarvings and important in tattoo.

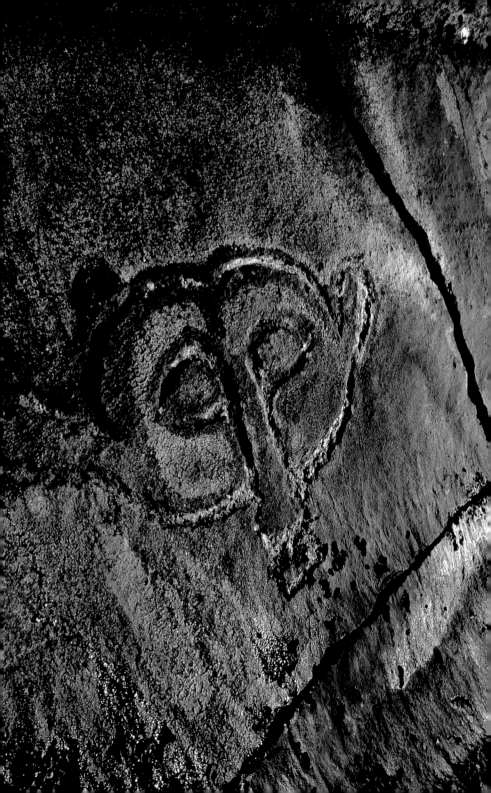

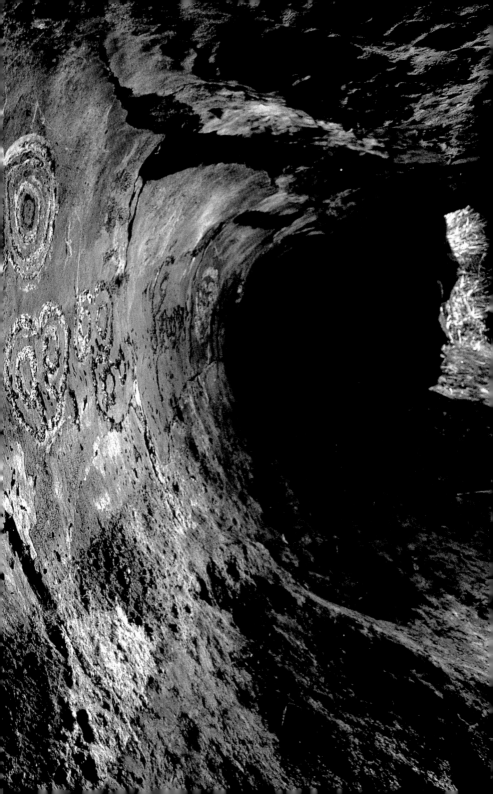

Birdman symbolism on Hoa Hakananai'a

A fundamental element of all *moai* is the incised line of the spine, which curves outward at the shoulder on both sides. It represents the sacred backbone of the chief, a symbol of genealogy. Hoa Hakananai'a lacks an incised spine, which may have been obliterated by superimposed carving (fig. 19). Triple bas-relief curved lines surmounted by a single circle create the loincloth (*maro*) motif and spatially divide the back into two design surfaces. The abstract double-chevron motif beneath the *maro* is the only symbol in the lower surface; in shape it is similar to the Y-shaped design on the chin.

In the upper portion of the design surface, above the *maro*, are carvings identifiable in form and ubiquitous in the island's corpus of rock art but extremely rare or never present on other *moai*. Some are low relief (about 1 cm high) and others incised. Not all were planned in relation to the others, and they may have been made by different individuals at different times. Carving and tattoo are related arts and created by similar tools. Decorating the human body with tattoo and superimposing petroglyphs on the back of an otherwise traditional *moai* are obviously related acts. Like tattoo designs, the carvings on the back of Hoa Hakananai'a are probably ideographic and link the statue directly to the birdman ceremonies.

The carvings, as we have seen (p. 36), were painted in red and white. Red and white paint was reported in several Orongo buildings and in Taura renga, which housed Hoa Hakananai'a. Palmer discovered at Vinapu that red and white paint was applied to some statues fallen from *ahu*. It was not applied, so far as is known, to Orongo petroglyphs, but is found on rock art in Rano Raraku and elsewhere (fig. 20).

On the statue's upper back and shoulders are placed two birdmen with human hands and feet, and frigate bird (*Fregata minor*, or *makohe*) heads. These are typical depictions of the birdman (*tangata manu*) as a representation or incarnation of Makemake. The birdmen are shown in profile, facing one another; contemporary Rapanui say that this face-to-face position suggests familial

or sexual relationships. In the space between the two birdmen are a number of disjointed lines. Although the birdmen are the most expertly executed of the superimposed symbols on this statue, they are less skilful than many others carved as petroglyphs at Orongo.

Above the heads of the birdmen and almost precisely in the middle of the back of the statue's head is the form of a small bird with open beak – implying a fledgling and the production of sound – and partially folded wings. It is an incomplete, confusing design with a shortened, thickened body resembling a fish. The overall shape of the bird/fish is awkward, but its posture and head/beak is similar to paintings on the interior slabs of Orongo buildings, on a few petroglyphs and on the ceiling of a large seaside cavern known as 'Ana Kai Tangata (fig. 21). These are said to depict the sooty tern (*manutara*), the seasonal harbinger of Makemake (see p. 23).

On each side of the bird we see a frontal, vertically placed *'ao*, or wooden ceremonial dance paddle. The *'ao* is a highly abstracted representation of a human male face/body, and it was carried as the symbol of power and prestige bestowed upon the reigning birdman. The back of the statue's left ear has been re-carved to include a third *'ao* which, because of its placement, is shorter than the other two. It may, therefore, be intended to represent the similar, shorter *rapa*. Both of these ceremonial objects were often painted red and white.

The right ear has four low-relief vulva (*komari*) symbols carved in a vertical line. Between the *'ao* at the top of the head are Y-shaped symbols that duplicate in incised form the bas-relief Y-shaped designs on the statue's chin and resemble the Y-shaped carving below the *maro*. Similar Y-shaped forms in other media, including rock art and anthropomorphic woodcarvings, are abstracted representations of birds, fish or the female genitalia (see fig. 21).

Conflicting details about Hoa Hakananai'a and its role during childhood initiation ceremonies and the birdman ceremonies were collected by Katherine Routledge in 1914–15 from elderly people who had participated as adults.

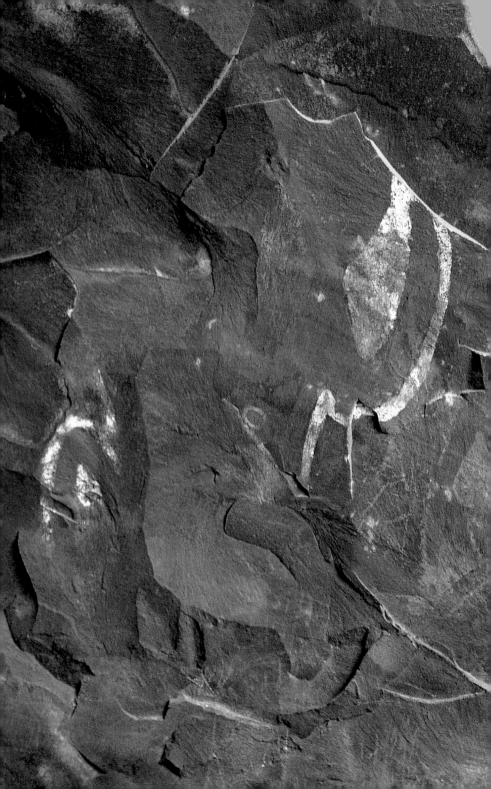

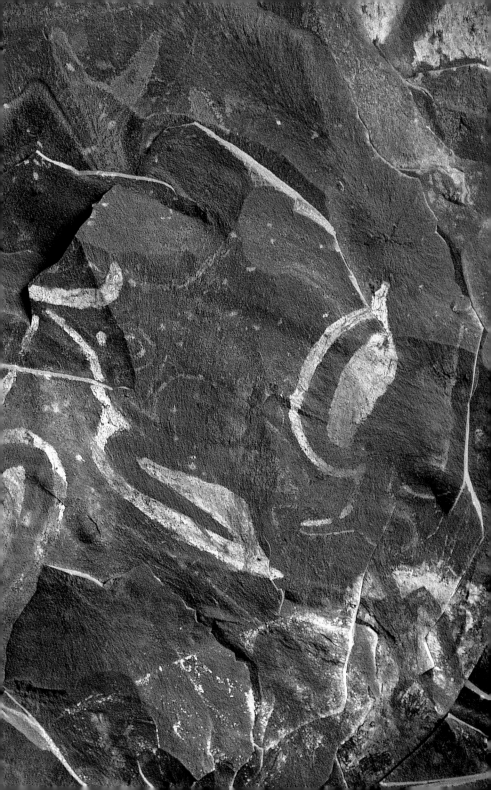

Routledge was the first researcher to note that Rapanui people understood an underlying ecological reason for the birdman ceremonies. Seabirds, they told her, 'used to be on the land but became frightened of being killed & went to live on the islands'.[10]

Routledge was told that participants in birdman ceremonies were drawn from the most prominent or ascendant clans and the warriors (*matatoa*) who dominated them. Everyone involved gathered at Mataveri (near where Moai Hava was found). Huge ceremonies focusing on fertility were held. When the time was right, the company ascended Rano Kau to Orongo where participants in the race for the first egg of the sooty tern were named and the winner celebrated.

Routledge collected a small stone statue on the off-shore islet of Motu Nui. Like Hoa Hakananai'a, it may have been first associated with a small, nearby *ahu*. It was found, also like Hoa Hakananai'a, hidden in a cave. The statue, which is a combination of *moai* and Makemake characteristics, is certainly late and may have been made with metal tools. It was said to be the 'boundary marker' that anchored a line dividing Rapa Nui into east/west districts. The line ascended the cliff of Rano Kau and divided the buildings at Orongo, as well, into east/west clusters. It ran right through the building Taura renga and past or through Hoa Hakananai'a.

In Rapanui, *taura* means 'string' or 'cord'; *renga* is a widely known Polynesian designation for the turmeric plant and the orange dye produced from its tuber. Called *pua* in Rapanui, turmeric was also esteemed for its fragrance. Taura renga might thus be an illusion to the red-stained loincloth (*maro*) of chiefly authority and status. Hoa Hakananai'a was said to have worn a special belt made of barkcloth rubbed with red pigment during coming-of-age ceremonies.

Rapanui children (*poki manu*, or 'bird children') participated in initiation ceremonies that appear to have evolved from the original Miru practice of secluding chiefly children. Their parents arranged the ceremony and paid the officiating priests in prized white-feathered chickens.

At the priests' direction the boys gathered in a semicircle in front of the doorway or on the roof of Taura renga, where Hoa Hakananai'a was housed, their backs to the sea. Like the statue, the children's bodies were adorned with designs in white paint, and they wore special wooden ornaments and white loincloths. The priests chanted, the wind swirled and distant birds called as the children raised tremulous voices and sang to the *moai*.

The girls, some of whom had apparently been confined for up to about three months prior to the rituals, gathered at Mata Ngarau, on the edge of Rano Kau. They stood on the carved rocks in front of the eight buildings said to have been occupied by *rongorongo* men. Priests examined their genitals and then carved a *komari* (vulva) petroglyph.

Like the Orongo petroglyphs and incised *rongorongo* symbols, the carvings on the back of Hoa Hakananai'a contain coded information. If we choose to be literal, the entire tableau may be interpreted as a commemoration of Orongo ceremonies. When 'read' from bottom to top, for example, we see two individuals who have achieved the sacred status of birdman (or one individual who did so twice). The power thus accrued by the related lineage is represented by the *'ao*. The bird with open beak may represent a young male child of the chosen lineage as it enters adulthood, and the *komari* symbols may relate to females of the same lineage.

Hoa Hakananai'a and ancestral history

Hoa Hakananai'a has the traditional form and, by implication, the same meaning as all *moai* raised on *ahu*. That is, it is a symbol of lineage identity dedicated to an ancestral god or gods. Its situation at Rano Kau places it within the context of the Miru. Its original location there is not known, but its function was very probably to legitimize the transfer of power from one season to another, and from one birdman to another within the Miru and directly related lineages.

Its secondary placement was in Taura renga, where its function changed. It marked the east/west boundary of the island and delineated the east/west division of

Orongo buildings during birdman ceremonies that grew increasingly larger and more competitive. It may have stood upright before being implanted in the earth, and then become hidden by the building constructed around it. This situation is not unique: there are other statues in various parts of the island that are found tucked away in caves, perhaps to protect them from damage by competing lineages.

The carvings on the statue's back, made before it was buried, present a superimposed record of events or, more probably, of Miru achievements at Orongo. Yet, even after it was hidden, the statue continued to function as a ritual object well into the missionary era. Such layers of meaning and function seem to me to be the legacy of Hoa Hakananai'a and precisely what its makers intended: an ancestral history carved in stone.

Since its removal from Rapa Nui, Hoa Hakananai'a has impressed the Western world. The famous sculptor Henry Moore remembered the power, dignity and authority of the statue when it stood on the colonnade of the British Museum. Artists such as Max Ernst, Paul Gauguin and Pablo Picasso, and Chile's great Nobel Laureate Pablo Neruda have been moved by the island and its *moai*. Neruda conceptualized Rapa Nui and its watery isolation as pure, secret and even feminine. The statues were 'solemn nobles', deliberately apart and inevitably lonely.

> Great pure heads,
> tall necks, grave faces,
> their immense square jaws
> prideful in their solitude,
> presences,
> arrogant presences,
> troubled.[11]

The American poet Robert Frost had his own impression of the *moai*, and penned a poem inspired by Hoa Hakananai'a:

> That primitive head,
> So ambitiously vast,

Yet so rude in its art,
Is as easily read
For the woes of the past
As a clinical chart.
For one thing alone,
The success of the lip
So scornfully curled
Has that tonnage of stone
Been brought in a ship
Halfway round the world.[12]

Other writers have responded to the island and its *moai* in less artful ways. Gallons of ink have been spilled in ships' journals and logs, often to the disadvantage of historical accuracy. All nineteenth-century visitors to Rapa Nui relied upon missionaries or colonial administrators for ethnographic information, and what they learned was fragmentary. Paymaster Richards, an officer aboard HMS *Challenger* in 1876, confused the record by culling several paragraphs about Rapa Nui from the ship's library and introducing them into his journal. This caused some to mistakenly believe that his ship had called at the island, and led to one writer who drew on Richards' accounts, in 1926, to attribute the collection of Hoa Hakananai'a to HMS *Challenger*.

Rapanui people survived their violent introduction to Western ways and their resulting, turbulent history. They adapted successfully to modern times while tenaciously seeking their own identity. The Rapa Nui National Park, including Orongo, was declared a World Heritage Site in 1995. There is also a fine museum on the island, and in 1995 it successfully collaborated with the British Museum to create an exhibit of Mana Expedition photographs. Mataveri, where Moai Hava was found, is now the site of a modern airport and tourism is thriving.

The role of Hoa Hakananai'a as a key object in the British Museum collection is justly celebrated: as all other *moai* it is a quintessential symbol of Rapa Nui, its remarkable people and their history.

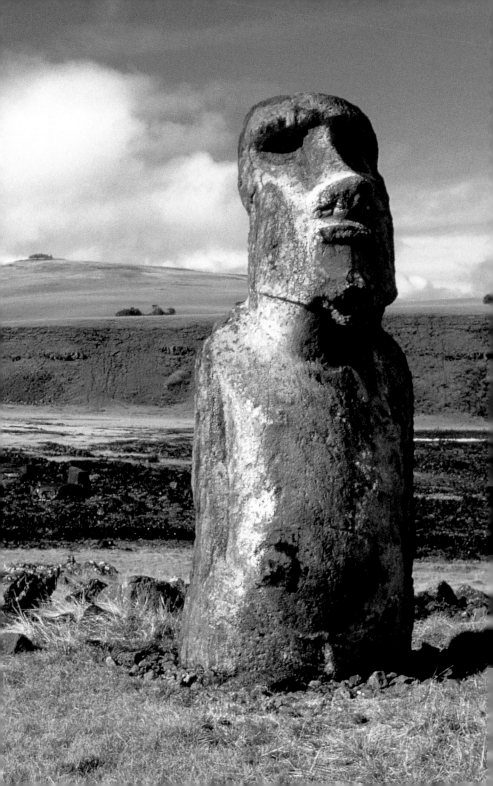

Notes

22 Looking east toward Pua Ka Tiki (Poike). One of the island's three formative volcanoes, it dominates Hotu Iti (east district). The *moai* were re-erected in modern times.

Du Feu (1996) is the source for glottal placement in Rapanui placenames on the map. In Fuentes (1960, 798), 'nanai'a' is written with the glottal.

1 Rapa Nui is the current official spelling of the island's name. Rapanui is the linguistically preferred name of the people and language.

2 Original Papers, 3 Dec. 1868, no. 109, and 25 Aug. 1869, f. 404, The British Museum Central Archives; Trustees Standing Committee, 9 Oct. 1869, c. 11, 718–9.

3 Dundas in National Library of Scotland, Acc. 10719/46.

4 *Ibid.*

5 Palmer, Royal Geographical Society Picture Library.

6 Sainthill 1870, 450.

7 Harrison, 'Journal and Remarks Book', 7 Nov. 1868 (Eth. Doc. 1108).

8 Sainthill 1870, 450. The name 'Hoa Hava' was also recorded (Van Tilburg 1992, 38).

9 Harrison, 'Journal and Remarks Book', 7 Nov. 1868 (Eth. Doc. 1108). Some linguists write Hoa Hakananai'ā.

10 Routledge in Van Tilburg 2003, 136.

11 Excerpt from Pablo Neruda, 'IX: The Island', translated by William O'Daly, from *The Separate Rose*. Copyright © 1973 by Pablo Neruda and the Heirs of Pablo Neruda. Translation © 1985 by William O'Daly. Reprinted with the permission of Copper Canyon Press, P.O. Box 271, Port Townsend, WA 98368-0271, USA.

12 Robert Frost in Lathem 1971.

59

Further reading

Caygill, M., *Treasures of the British Museum* (London, British Museum Press, 1985).

Du Feu, V., *Rapanui* (London and New York, Routledge, 1996).

Ferdon, E.N. Jr, 'The ceremonial site of Orongo' in T. Heyerdahl and E.N. Ferdon Jr (eds), *Reports of the Norwegian Archaeological Expedition to Easter Island and the East Pacific, Vol. 1, Archaeology of Easter Island* (Santa Fe: Monograph of the School of American Research and the Museum of New Mexico 24, 1961).

Fuentes, J., *Dictionary and Grammar of the Easter Island Language: Pascuense-English, English-Pascuense* (Santiago, Andrès Bello, 1960).

Kaeppler, A.L., 'Rapa Nui art and aesthetics' in E. Kjellgren (ed.), *Splendid Isolation: Art of Easter Island* (New York, The Metropolitan Museum of Art and Yale University Press, 2001).

Kirch, P.V., *On the Road of the Winds: An archaeological history of the Pacific Islands before European contact* (Berkeley, University of California Press, 2000).

Lathem, E.C., *The Poems of Robert Frost*, Vol. 2 (Barr, Massachusetts, The Imprint Society, 1971).

McCall, G., *Rapanui: Tradition and survival on Easter Island* (Honolulu, University of Hawai'i Press, 2nd edn, 1994).

Métraux, A., *Ethnology of Easter Island*, Bernice P. Bishop Museum Press Bulletin 160 (Honolulu, 1940).

Moore, H., *Henry Moore at the British Museum* (London, British Museum Press, 1981).

Mulloy, W., *Investigation and Restoration of the Ceremonial Center of Orongo, Easter Island*, Bulletin 4, Easter Island Committee (New York, International Fund for Monuments, 1975).

Routledge, K., *The Mystery of Easter Island* (London, Sifton, Praed and Co., 1919).

Routledge, K., 'Survey of the village and carved rocks of Orongo, Easter Island, by the Mana Expedition' in *The Journal of the Royal Anthropological Institute of Great Britain and Ireland* 50 (1920), 425–51.

Van Tilburg, J., 'HMS *Topaze* on Easter Island: Hoa Hakananai'a and five other museum statues in archaeological context', *Occasional Paper* 73, London, Department of Ethnography, The British Museum (1992).

Van Tilburg, J., 'Changing faces: Rapa Nui statues in the social landscape' in E. Kjellgren (ed.), *Splendid Isolation: Art of Easter Island* (New York, The Metropolitan Museum of Art and Yale University Press, 2001).

Van Tilburg, J., *Among Stone Giants: The life of Katherine Routledge and her remarkable expedition to Easter Island* (New York, Scribner's, 2003).

Publications and papers by
HMS *Topaze* crewmembers

Barclay, Capt., 'The lost land of
the Maoris: What we found at
Easter Island' in *Life* 13 (1910),
373–6.

Department of Ethnography, The
British Museum, Eth. Doc. 974.
Photocopies of all of the known
published accounts of the 1868
visit of HMS *Topaze*. Cross-
referenced to Eth. Doc. 1108.

Dundas, C., 'Notice of Easter
Island, its inhabitants,
antiquities, and colossal statues'
in *Proceedings of the Society
of Antiquaries of Scotland* 8
(1870), 312–20.

Dundas, C., 'The [Peruvian]
earthquake and great wave
13 August 1868: after the
earthquake – by a naval officer'
in *Mission Life* (1877; National
Library of Scotland, Ramsay
and Dundas of Ochtertyre,
Acc. 10719).

Harrison, Lt M.J., Department
of Ethnography, The British
Museum, Eth. Doc. 1108.
Sketches are in the Pictorial
Archive. Cross-referenced to
Eth. Doc. 974.

National Library of Scotland.
Ramsay and Dundas of
Ochtertyre. Acc. 10719,
including C. Dundas, logs of
HMS *Topaze* and misc. Easter
Island papers, items 39–49.

Palmer, J.L., 'Observations on the
inhabitants and the antiquities
of Easter Island' in *Journal of
the Ethnological Society of
London* 1 (1869), 371–7.

Palmer, J.L., 'A visit to Easter
Island, or Rapa Nui' in *Royal
Geographical Society
Proceedings* 14 (1870), 108–19.

Palmer, J.L., 'A visit to Easter
Island, or Rapa Nui, in 1868'
in *Royal Geographical Society
Journal* 40 (1870), 167–81.

Palmer, J.L., 'Davis or Easter Island'
in *Literary and Philosophical
Society of Liverpool Proceedings*
(1875), 275–97.

Powell, W.A., 'Detailed report on
Easter Island, or Rapa Nui' in
*Royal Geographical Society of
Australasia, South Australian
Branch, Proceedings* 3 (1899),
138–42.

Sainthill, R., 'Rapa Nui or Easter
Island' in *Macmillan's
Magazine* 21 (1870).

Rapanui words

ahu	ceremonial platform[s]
Ahu Moai Phase	*moai*-carving phase of Rapanui history, AD 1000–1600
ʻAnakena	royal residence, on the north shore of the island within the Tuʻu district
ʻao	long, wooden ceremonial paddle
ariki	chief[s]
ariki mau	hereditary, paramount chief
hami (or *maro*)	loincloth
Hotu Iti	eastern, lower-ranked of the island's two political districts
Hotu Matuʻa	legendary first Rapanui paramount chief
kohau rongorongo	wooden boards incised with carved symbols
komari	vulva, vulvae
Makemake	Rapanui creator god
mana	sacred or magical power
Miru	highest-ranked lineage on Rapa Nui
moai	statue

Orongo	ceremonial centre on Rano Kau and epicentre of the birdman religion
poki manu	bird children
pukao (or *hau*)	red cylinders balanced on the heads of some *moai*
Rano Kau	volcano, the site of the birdman religion
Rano Raraku	volcanic crater where nearly all *moai* were produced
rapa	short ceremonial paddle
Rongo	Rapanui ancestral god
rongorongo	chanting
tangata manu	birdman
Tangaroa	Rapanui ancestral god
tangata rongorongo	expert chanters/rongorongo men
tapu (*tabu*)	restrictions
Tu'u	western, higher-ranked of the island's two political districts
Tu'u Ko Ihu	legendary Rapanui carver

Photographic credits